DEXTER DALWOOD
ANGELA DE LA CRUZ
THE OTOLITH GROUP
SUSAN PHILIPSZ

The Turner Prize will be awarded at Tate Britain on
6 December 2010, during a live broadcast on Channel 4,
to an artist under fifty, born, living or working
in Britain, for an outstanding exhibition or other
presentation in the twelve months before 27 April 2010.

An exhibition of work by the shortlisted artists:
5 October 2010 – 3 January 2011, Tate Britain

– Dexter Dalwood –
has been nominated for his solo exhibition
at Tate St Ives, which revealed the rich
depth and range of his approach to making
painting that draws upon historical
tradition as well as contemporary cultural
and political events.

– Angela de la Cruz –
has been nominated for her solo exhibition
After at Camden Arts Centre, London.
De la Cruz uses the language of painting
and sculpture to create striking works
that combine formal tension with a deeper
emotional presence.

THE ARTISTS

– The Otolith Group –
has been nominated for their project
A Long Time Between Suns, which took the
form of exhibitions at Gasworks and The
Showroom, London, with an accompanying
publication. The collaborative and
discursive practice of The Otolith Group
questions the nature of documentary
history across time by using material
found within a range of disciplines, in
particular the moving image.

– Susan Philipsz –
has been nominated for the presentations
of her work Lowlands at the Glasgow
International Festival of Visual Art and
Long Gone in the group exhibition Mirrors
at MARCO Museo de Arte Contemporánea de
Vigo, Spain. Philipsz uses her own
voice to create uniquely evocative
sound installations that play upon and
extend the poetics of specific, often
out-of-the-way spaces.

– Isabel Carlos –
Director, Centro de Arte
Moderna José De Azeredo
Perdigão, Lisbon

– Philip Hensher –
Novelist, critic
and journalist

– Polly Staple –
Director,
Chisenhale Gallery,
London

THE JURY

– Andrew Nairne –
Executive Director,
Arts Strategy,
Arts Council England

– Penelope Curtis –
Director,
Tate Britain
and Chair of the Jury

PREVIOUS WINNERS

2009	Richard Wright
2008	Mark Leckey
2007	Mark Wallinger
2006	Tomma Abts
2005	Simon Starling
2004	Jeremy Deller
2003	Grayson Perry
2002	Keith Tyson
2001	Martin Creed
2000	Wolfgang Tillmans
1999	Steve McQueen
1998	Chris Ofili
1997	Gillian Wearing
1996	Douglas Gordon
1995	Damien Hirst
1994	Antony Gormley
1993	Rachel Whiteread
1992	Grenville Davey
1991	Anish Kapoor
1990	Prize suspended
1989	Richard Long
1988	Tony Cragg
1987	Richard Deacon
1986	Gilbert and George
1985	Howard Hodgkin
1984	Malcolm Morley

FOREWORD

Suppose we don't think of the Turner Prize as a competition but simply as a prize: a prize for an outstanding presentation of a single artist's work. This helps move us away from something that is nearly impossible – judging one artist's work against another – towards something much more possible – judging one exhibition against another, but also against exhibitions by the same artist in the past. Thus we start to arrive at what is, for the Turner Prize, a point of departure. Artists have many exhibitions, but only a few seem to capture qualities of the work as a whole that have perhaps only been hinted at previously. The Turner Prize then is enormously dependent on the work that goes on all the time, around the UK and abroad, in determining the best way to show art.

Curators and critics working in the field of the visual arts have to spend a lot of time travelling. We go to the exhibitions, because they cannot travel to us. For the work of selection we are indebted to this year's jury: Isabel Carlos, Philip Hensher, Andrew Nairne and Polly Staple.

Here at Tate Britain we do our best to represent the work that attracted the judges' attention. Impossible as it is to recreate the original exhibitions, we work instead with the artists either to showcase these works, or to choose other appropriate work of a similar character. Whereas the nominated exhibitions were shown in spaces and contexts that varied enormously, Tate Britain's galleries inevitably smooth out such variations and instead present the artists' work on a more equal footing.

For their help in translating the artists' practice to this new context we are grateful to the artists' galleries, lenders and other individuals, including Tanya Bonakdar and Ethan Sklar at Tanya Bonakdar Gallery, New York; Hannah Freedberg at Gagosian Gallery, London; Greg Hilty and Juliette Rizzi at Lisson Gallery, London; Fern and Lenard Tessler; Alan and Sherry Koppel; TransArt & Co. Collection, Cartegena and Galerie Krinzinger, Vienna. Taking part in the Turner Prize is a demanding process and we are grateful to the artists for working with us so wholeheartedly. They have been supported throughout by curators Helen Little and Katharine Stout.

Twenty-six years after the prize was initiated its accompanying furore has generally declined. This leaves us a space in which we can think about how varied art can be, and how challenging it is to make an exhibition – never mind a prize – which conveys its many possibilities. Whatever the outcome of the judges' decision on 6 December, we know that this exhibition highlights the work of four individual, rigorous and highly evolved artistic practices.

Penelope Curtis
Director, Tate Britain

1960 Born Bristol, UK
Lives and works in London

———

DEXTER DALWOOD

———

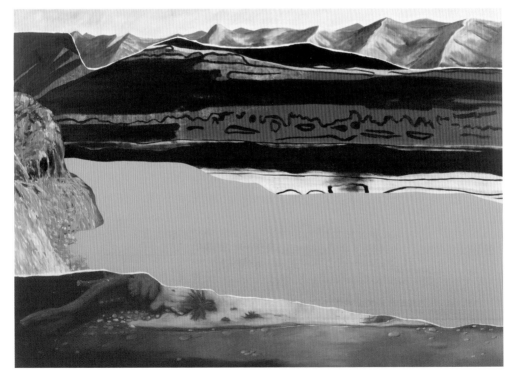

Dexter Dalwood <u>Lennie</u> 2008

The idea that there is no single version of reality, that our understanding of the past and present is made up of different memories and viewpoints, some coinciding, some conflicting, is an accepted concept today. Dexter Dalwood's arresting paintings give pictorial form to this notion of a portrayal of individuals or events that have shaped history, culture and society as an aggregation of fragmented stories, images and perspectives. His choice of themes is wide-ranging and surprising, each work driven by his incessant curiosity. This results in Dalwood researching a subject thoroughly in order to produce an entirely new visual testament to an often well-known topic. The tradition of figurative painters who have responded to events unfolding in the world rather than developing a more formal, hermetic practice is distinguished and can be traced from Delacroix to Philip Guston to Gerhard Richter. Pursuing this line of enquiry under contemporary conditions, Dalwood has developed a form of representation that explicitly acknowledges the formal and conceptual innovations of such iconic predecessors. Sampling becomes a language rather than a device, which allows Dalwood the creative freedom within his own studio-based practice to fluently merge and reinvent borrowed modes of figuration and abstraction from across art history. The resulting image remains convincing and surprising whilst drawing attention to itself as a construct.

Early paintings for which Dalwood became celebrated in the late 1990s can be described as interiors that depict the last known location of celebrities such as Jimi Hendrix and Sharon Tate, who have become famous as much for the shocking violence and tragedy of their deaths as for their lifetime achievements. A consistent feature of his work is that the main protagonist does not appear; instead, Dalwood's intention is to render an atmosphere that evokes that character in a particular time and place. After an initial sketch of an identified theme has been drawn, Dalwood turns to collage, which becomes the template for the much larger-scale painting. By layering and juxtaposing cut-up or torn fragments of imagery taken from magazines and art history books he carefully builds up an interior or landscape scene.

The thinking and working spaces of writers such as Oscar Wilde, Herman Melville and William Burroughs is the motivation for another ongoing group of paintings. *Burroughs in Tangiers* 2005 is a key work not least because Burroughs's process of splicing together cut-up text to create experimental writing is another important influence on Dalwood. The selection of Robert Rauschenberg's *Rebus* 1955 (painted contemporaneously to Burroughs's most famous book, *Naked Lunch*, first published in 1958) as the ground for Dalwood's portrait introduces another layer of appropriation and collage. Dalwood faithfully reproduces and pastes onto his own painting the found imagery of Rauschenberg's original such as the comic strip, a colour chart and Botticelli's *Birth of Venus*, alongside repainted 'drippy' areas of flat colour. He re-imagines the borrowed abstract surface as a figurative scene by introducing the tropical foliage of Matisse's *The Moroccans* 1915 – 16 for the bed and collaged images of furniture such as the writer's famous typewriter, which act as indexical signs for Burroughs's Moroccan apartment. By combining an overall 'flatbed' plane with more recognisable figurative elements, the painting succinctly captures the sense of chaos that the poet Alan Ginsberg encountered in Tangiers when he discovered Burroughs high on Eukodol, his manuscripts scattered all over the room.

A related, more recent series comprises landscape paintings that depict characters from literature. *Lennie* 2008, for example, is based on a figure in John Steinbeck's classic novel,

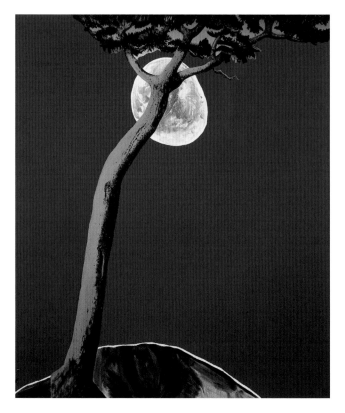

Dexter Dalwood <u>Death of David Kelly</u> 2008

Of Mice and Men (1937), set during America's Great Depression. This painting imagines the last scene, in which George reluctantly shoots his simple-minded friend to avoid him being lynched, after Lennie accidentally kills a young woman. Without the melodrama of the figures in question, the image remains ambiguous and formally playful, despite the poignant subject matter. The central sweep of vibrant pea green that recalls both the river and the agonising potential of the friends' unrealised dreams for the future give the work a distinct presence and charge that cannot be reproduced in print. Dalwood's use of a solid plane of colour in combination with elements of figuration draws upon the distinct characteristics of traditional Indian miniature painting, which he observed at length during an extended stay in India. The shallowness of the picture plane, which pushes to the fore a very physical sense of space, gives recent works a different feel from earlier paintings that depict a more enclosed, interiorised space to evoke the mood and psyche of the personality in question.

The use of an abstract, flat colour to give the work a strong visceral presence has been exploited further in Dalwood's latest works such as *Brighton Bomb* 2006 or *Greenham Common* 2008, which deal with political events that took place in Britain. These follow an earlier move into the classical genre of history painting by portraying events that defined

the structure and outlook of the Western world, as in *Bay of Pigs* 2004, *Birth of the UN* 2003 and *Yalta* 2006. The sensory, expansive flood of intense blue in the painting *Death of David Kelly* 2008 elicits a pleasure of looking that is at odds with the trauma and, by implication, enormity of the subject matter revealed in the title. This is political history so recent and raw that it is potentially more personal and immediate to a British audience, as to the artist himself, than earlier events that Dalwood has depicted.

It comes as no surprise that Dalwood had an early, brief career as a musician, since the use of appropriation and sampling runs throughout contemporary culture but is particularly prevalent in both popular and classical music. Yet although he brings a remarkable knowledge of art history, music, literature and history to his work, he thinks and responds as a painter. Dalwood's quiet ambition is that his works will prompt the viewer to reappraise the significance of a particular moment in time, in a way that connects with and expands upon the history of painting. Katharine Stout

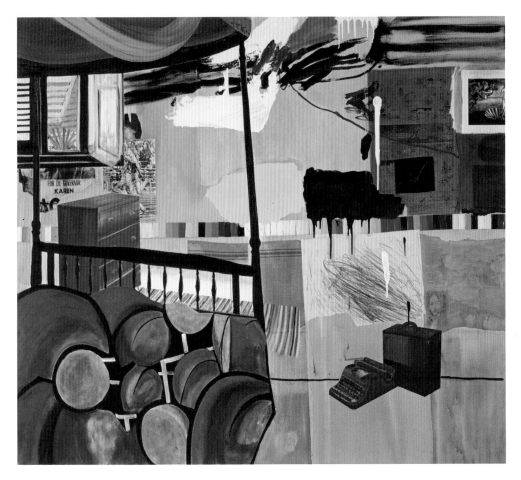

Dexter Dalwood <u>Burroughs in Tangiers</u> 2005

1965 Born La Coruña, Spain
Lives and works in London

––––––

ANGELA DE LA CRUZ

––––––

Angela de la Cruz interrogates the medium of painting in order to ask, 'When is a painting not a painting?' Her formally innovative practice unpacks the conventions, limits and methods of the medium to make works that, while concerned with their status as paintings, cannot necessarily be considered as such. After breaking the stretchers of her canvases as a student, de la Cruz became occupied with liberating painting from the sacred boundaries of its support, allowing it to expand from the flat picture plane into a third dimension. Beginning life as traditional rectilinear paintings on canvas, her works are subjected to unusual and often violent physical distortions that redefine and renew the medium. Crudely broken, ripped or folded in on themselves, awkwardly wedged into corners and doorways, deliberately soiled or presented as masses on the gallery floor, de la Cruz's visually intriguing objects open up new possibilities for painting as both object and image.

Despite its cool minimal style and overt reference to the modernist canon, de la Cruz's vocabulary is highly personal and emotionally charged, rooted in everyday experiences and the world around us. Her engagement with paint is a physical one, and she considers the stretcher an extension of the body. As a result, her works often allude to or stand in for the human form, either through their evocative configurations, scale or subtle activation in the gallery. Her series *Everyday Paintings* 1995 – 9 can be described as figurative objects, but not paintings of a figure. The twisted and convoluted forms of the component works, including *Ashamed* 1995, *Crash* 1997, *Fallen on Your Own Butt* 1997 and *Knackered* 1998, suggest various physical states and human frailties, their literal titles setting forth a disquieting

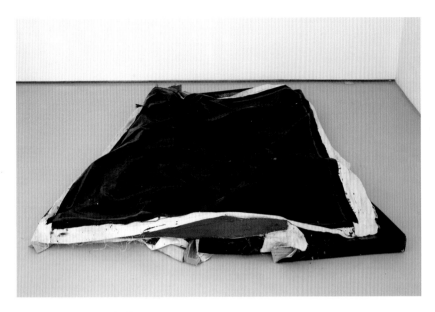

Angela de la Cruz _Clutter I_ 2003

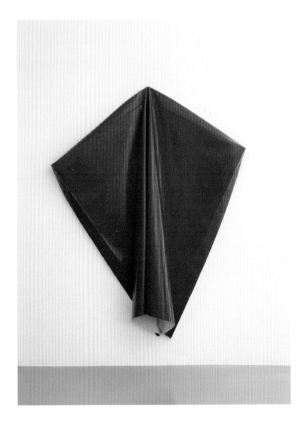

Angela de la Cruz _Deflated IV_ 2010

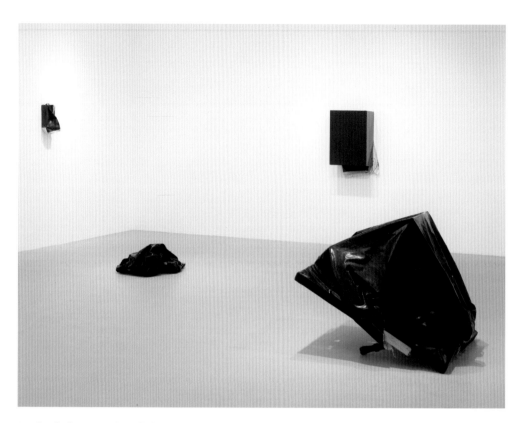

Angela de la Cruz, from left to right: <u>Ready to Wear VI</u> 1998; <u>Nothing</u> 1998; <u>Torso</u> 2004 and
<u>Still Life (Table)</u> 2000. Installation view, <u>After</u>, Camden Arts Centre, 2010

notion that something has happened, or is about to. Their surfaces are equally abject, in
many cases smeared or stained the colours of bodily fluids. Eschewing painting as we
know it, these violent acts result in highly animated objects that become active as they
enter into a relationship with the viewer.

Despite their brutally misshapen and dilapidated forms, de la Cruz's more recent
canvases can be described as deftly and luxuriously painted monochromes, their slick,
fetishised surfaces and painted borders reinforcing their sculptural appearance. *Hung XI*
2010 is a small, perfectly painted monochrome that, despite being 'hung' conventionally,
has not escaped damage or accident, as its crumpled edges testify. *Deflated IV* 2010
dispenses with the stretcher altogether. Here, a sheet of glossy canvas hangs from a screw
in the wall, as if it were a coat on a hook. A number of de la Cruz's works deal with the
dilemma of 'a painting too many', and the monochrome format has enabled the artist to
make a body of work about commodity and repetition. Seductive canary yellows, fuschia
pinks and military greens find their way into the works via the world of high-fashion,
signifying the must-have shades of the season, and the materiality of painting. Her series
Clutter, 2003 – ongoing, conceived as a way to recycle disregarded materials from around
the studio, overtly plays on the notion of excess production. The *Clutter* paintings are

made up from existing canvases that have already fulfilled their function as paintings and have somehow overgrown themselves or passed their use-by date. The first in this series, *Clutter I* 2003, comprises a number of old, dishevelled paintings salvaged from the studio. Stacked on the floor, layers of broken paintings with protruding stretcher bars are discernible from beneath a single sheet of painted black canvas, resembling a protective shield or 'blanket'. Born out of newspaper images of the atrocities of the Iraq conflict and in later works the Madrid bombings, the series gives abstract form to the use of body bags to transport the dead. Expanding the artist's ideas about containment, *Super Clutter XXL (Pink and Brown)* 2010 is an elaborately twisted canvas that, by virtue of its intricate folding, is able to function like a 'bag', sometimes carrying several paintings – and the weight of their history – inside. Taken out of their misery, excess canvases and older paintings are now restored and transfigured as functional new works.

A more recent, parallel body of work builds on the artist's fascination with volume, mass and gravity, juxtaposing painting with everyday objects and furniture selected for their human scale. From using paintings as containers, de la Cruz has begun to utilise real containers such as filing cabinets and wardrobes. In *Torso* 2004, a box containing old canvases and made to the exact measurements of the artist's body is hung on the wall. In the twin piece *Untitled (Hold no. 1)* 2005, a metal filing cabinet is also solidly attached to the wall. A second coffin-like metal container, the height and weight of which corresponds to that of the artist, is suspended from it, trying to remain stable. Being heavier and more voluminous than canvas, these objects perform a precarious, almost humorous, balancing act. Uniformly painted, and in a negation of the sculptural form, when viewed from the front these works give the illusion of being two-dimensional.

In the YouTube clip *El santo se cae* (The Saint is Falling),[1] a life-sized effigy of the Holy Virgin is carried ceremoniously towards a church altar, only for it to topple from its support and smash to the floor, to the horror of the congregation. The almost slow-motion footage of the saint teetering in space before its dramatic demise captures the irreverence of de la Cruz's practice. Like the Spanish literary tradition of the *picaresque* or the Chaplin-esque characters of the slapstick films she admires, her objects pull through their struggles and exhaustion with comedic integrity. Impulsive and systematic, minimal yet expressive, de la Cruz's methodology of breaking down, patching up and re-assembling her works opens them up to new possibilities and a stimulating reinvention of the language of painting.

Helen Little

The Otolith Group was founded in 2001 by
Kodwo Eshun and Anjalika Sagar
1966 Kodwo Eshun Born London, UK
1968 Anjalika Sagar Born London, UK
The Otolith Group live and work in London

———

THE OTOLITH GROUP

———

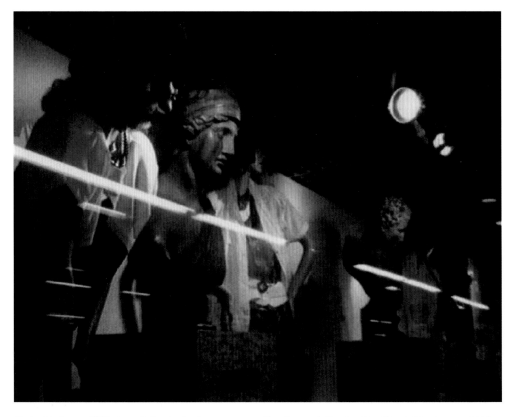

Chris Marker, still from Episode 9: Cosmogony or The Ways of the World, The Owl's Legacy 1989

Through films, photoworks, curatorial projects, writings and discussions, The Otolith Group explores the capacity of the essayistic to exploit the seductive power of the moving image, whilst concurrently questioning and destabilising it, in order to re-imagine notions of truth and history. Their films merge archival material with new footage and fictionalised sequences, in particular employing science fiction to move playfully between the temporalities of past, present and future and break down distinctions between the real and the imagined. There is growing recognition of the importance of making archives visible, yet the Group goes beyond simply revealing new sources of information, instead using forgotten moments to reinvigorate images and indeed histories that are over-determined and over-exposed. As the narrator of *Otolith I* 2003 states: 'For us, there is no memory without image. And no image without memory. Image is the matter of memory.' Layered and subtly overlapping themes and references repeat and mutate from film to film, developing a distinct language that investigates the conditions of the present and potentiality of the future through a rethinking of the past.

For the Turner Prize exhibition, The Otolith Group presents *Inner Time of Television* 2010, a collaborative project with Chris Marker. The work reconfigures the French film-maker's thirteen-part television series about Ancient Greek heritage, *The Owl's Legacy*, as an installation with accompanying artists' book, allowing a new audience to encounter this remarkable series, lost after its 1989 broadcast in France and Britain.[1] Rather than presenting a straightforward narrative, *The Owl's Legacy* explores the idea of Greece and its legacies within such themes as misogyny and cosmogony through the words of classicists, filmmakers, dramatists and others. With the constant motif of the Owl appearing in different forms throughout, the commentaries are mischievously juxtaposed to undercut each other, whilst expanding upon the opinions of the previous speaker. This series came out of a time (evidenced in the reduced analogue quality of the exhibited episodes) when television was still regarded as a site for exploring intellectual ideas through experimental and creative means. As the Group comments: 'What is clear is that a television series such as *The Owl's Legacy* could never be broadcast on British television today.'[3] All thirteen episodes are given simultaneous spatial presence within the gallery, allowing the opportunity to take in the series as a whole, as well as to view programmes individually, displacing the documentary from the sequential logic of its original television format. *Inner Time of Television* reiterates that the context for moving-image work that defies the conventions of television making, or mainstream cinema, has largely shifted to the forum of art.

Having met in 2000, Kodwo Eshun and Anjalika Sagar formed The Otolith Group in 2001. They take from Marker, Black Audio Film Collective and others, the principle that the voiceover does not have to be in agreement with the images, and images can question other images.[3] *Otolith I* 2003 takes film clips of the encounter between Sagar's grandmother, Anasuya Gyan Chand and Valentina Tereshkova, the first female cosmonaut to orbit the earth, at a National Federation of Women conference in Moscow in 1972, and interweaves them with television coverage of international anti-war protests in 2003 and footage of Sagar's training in microgravity at the Yuri Gagarin Cosmonaut Training Centre, Star City. In the opening epigraph dated 2103, the fictional Dr Usha Adebaran Sagar describes the evolution of the human species, born in microgravity and therefore exiled in space, unable to tolerate the pressures of gravity on Earth. The mutated otolith, a part of the inner ear that senses gravity and motion, gave the Group their name and links the trilogy, which is

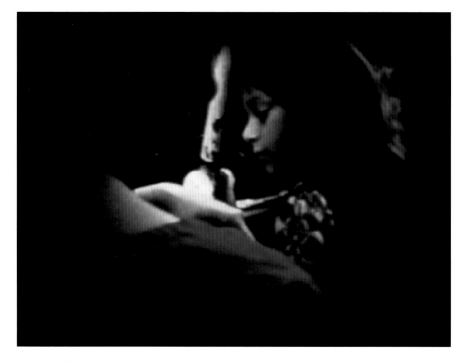

The Otolith Group, Canal 1972 from Otolith I 2003

further extended by the publication *A Long Time Between Suns*.[4] *Otolith I* powerfully contrasts the determined despair experienced by millions protesting against the imminent war in 2003 with an affirmation of the utopian visions of the past through the medial perspective of the future anterior.

Otolith II 2007 is set in the near future and juxtaposes different conditions of modern India – using the examples of the modernist city of Chandigarh planned by Le Corbusier in 1963, scenes of Mumbai's mega-slums today and footage of the Indian advertising industry – with Dr Usha's voiceover, which excavates fictional letters written by Sagar to her grandmother. The film negotiates the difficulty of portraying urban conditions that have been filmed repeatedly: 'You have to think about how your camera can suggest a critique of other uses that cameras are put to.'[5]

Otolith III 2009, presented in this exhibition, possesses a different atmosphere from the preceding works. It returns to 1967 when the film-maker, novelist and composer Satyajit Ray was writing the extraordinary unrealised screenplay, *The Alien*, in which a young boy from a remote Bengali village befriends a visiting extra-terrestrial. The characters of the Engineer, the Journalist, the Industrialist and the Boy are extracted from the unmade vision of *The Alien* to be given a voice in the contemporary world of *Otolith III*, as they seek to realise themselves as images. *Otolith III*'s polyvocal narration amounts to a series of rewritings of film history, drawing upon works by Pier Paolo Pasolini and other film makers, which never coalesce into a single narrative but instead reconsider the implications

of what T.J. Demos calls the 'unfinished encounter' with the alien of Ray's screenplay. More dreamlike than its predecessors, *Otolith III* reveals the Group's fascination with unfinished or unmade projects buried within film history. This is the underlying theme for the third aspect of their exhibition, a quartet of events that invite speakers to engage in close readings of rarely seen essayistic works that exemplify divergent modes of 'image thinking'.

Having trained and worked previously in other disciplines, Eshun and Sagar as The Otolith Group create artworks that offer deliberately fractured and uncertain visualisations situated at the intersection between tricontinentalism,[6] science fiction and essayism in all its forms. Their elusive, restless works emerge from and return to subjective accounts of historical conditions, configuring the resources of personal memoir as shared encounters that invite contemplation of the ways in which 'many of these histories' are held 'within memoir'.[7]

Katharine Stout

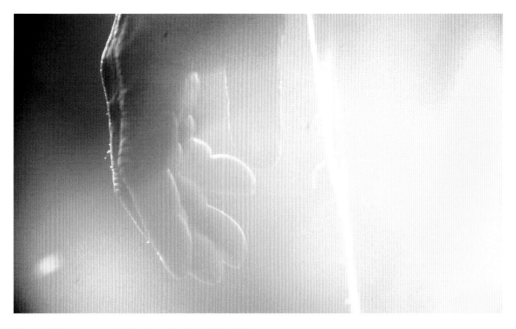

The Otolith Group, still from <u>Otolith III</u> 2009

1965 Born Glasgow
Lives and works in Berlin

———

SUSAN PHILIPSZ

———

Occupied with the ways in which sound and space can define and mediate each other, Susan Philipsz creates subtle audio installations where the artist's voice is the central medium. Drawing on the powerful, immersive effects of sound and engaged with the notion of singing as a physical and sculptural experience, Philipsz records her own unaccompanied versions of popular or folk songs that she replays in public spaces or in galleries. Her aural interventions explore the behaviour and effects of sound, exploit the medium's transience and dissemination, and examine how sound modifies and enhances spaces as it gradually permeates them. Irrevocably tied to the body, the capacity for the human voice to be both an internal and external force is played out repeatedly in Philipsz's work. As the artist has commented, 'The inhaling and exhaling of air, how the diaphragm controls the air as it goes through the lungs, make(s) you aware of your inner body space. When projecting my voice I became conscious of filling the room with sound and this led to thinking about architecture and how sound could define space and how sometimes the space could change the sound.'[1]

Philipsz often realises her audio works in unanticipated or out-of-the-way locations, allowing the discovery or history of a site to inform and shape their making. In doing so she gently intervenes in public consciousness. Whether encountered in a stairwell, supermarket or on a promenade, the artist's voice interjects through the ambient noises of the everyday, prompting collective and subjective recollections or meditative introspection. In *Filter* 1998 Philipsz played her own a cappella renditions of songs by Radiohead, Marianne Faithfull, Nirvana and The Velvet Underground through the public-address system of a

Susan Philipsz <u>Filter</u> 1998. Installation view, Laganside Buscentre, Resonate, Belfast 1998

Susan Philipsz <u>Stay With Me</u> 2005. Installation view, Malmö Konsthalle, 2005

busy bus station. In the loaded context of the station as a site for departure and arrival, Philipsz's vocals became emotionally disarming triggers for reflection on the experience of being at that place at that particular time. More recently, in *Long Gone* 2009, visitors to MARCO Museo de Arte Contemporánea de Vigo were greeted at its entrance by loudspeakers broadcasting Philipsz's version of the elegiac Syd Barrett song of the same name. Playing an integral part in the work, the public become caught in a dialogue between the singer and the listener that creates a new awareness of a familiar space.

Whether through the lyrics of the songs or the setting, themes of longing and escapism are recurring subjects in Philipsz's works. For the three-channel sound installation *Lowlands* 2010 the artist has recorded three versions of the sixteenth-century Scottish lament *Lowlands Away*, as documented in Stan Hugill's *Shanties of the Seven Seas* (1961). Redolent of the Scottish lowlands of the artist's origin, each version of the ballad tells the story of a drowned lover returning to his or her sweetheart as a ghost to mourn the fact that they will never be together again. The artist's rendition begins with three verses playing simultaneously with equal balance, gradually becoming more complex and fractured as the narratives intertwine and overlap, coming together at the refrain and parting again. Each channel varies in length so that in the end only one voice can be heard:

All green and wet with weeds so cold,
Lowlands, lowlands, away my John,
Around his form green weeds had hold,
My lowlands away

'I'm drowned in the lowland seas,' he said,
Lowlands, lowlands, away my John,
'Oh, you an' I will ne'er be wed,'
My lowlands away

'I shall never kiss you more,' he said,
Lowlands, lowlands, away my John,
'Never kiss you more – for I am dead,'
My lowlands away

'I will cut my breasts until they bleed,'
Lowlands, lowlands, away my John,
His form had gone – in the green weed,
My lowlands away

As the poignant sequences unfold in continual dialogue, Philipsz's vocals multiply and expand in the space, invoking the spectral figures not only in the melancholic sentiment of the song but also in how it is sung, how it is repeated, as if to bring back something that is gone.

Philipsz employs repetition as a device to alter our perceptions 'through the unhurried, cyclical and soothing effect of the sound', and the timbre, pauses and breaths of her vocals make it possible for us to relate intimately to the artist's body.[2] Dependent on our

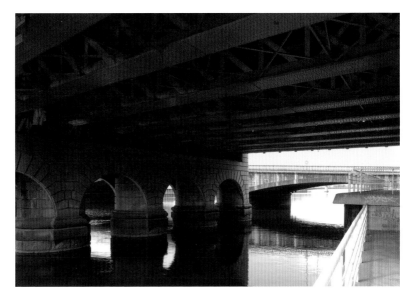

Susan Philipsz Lowlands 2008/10. Installation view, Clyde Walkway, Glasgow
International Festival of Visual Art, 2010

proximity to its source, we respond to her voice as we move through and around the space, our presence contributing to its material reflection, intensity and how it is communicated. However, the acoustical allusion of her body is shattered as we in turn become increasingly aware of our own physicality and occupation of the space. This paradox is brought to the fore when Philipsz re-presents the same works in different sites, subtly changing their physical properties and meaning with each new context. When installed outdoors on Glasgow's river Clyde, *Lowlands* reverberated back and forth from under the city's three bridges and the surface of the water, the loaded combination of the site and lyrics awakening powerful and redolent visual images. Devoid of such visual stimuli, the presentation of *Lowlands* in this year's Turner Prize exhibition offers a different, unique encounter. By installing her work in a starkly vacant gallery, Philipsz invites us to enter and explore the 'interior space of the work of art',[3] experiencing the intimacy and emptiness of the space simultaneously.

Our experience of Philipsz's sonic installations, recorded in a straightforward style and without falsetto, is akin to eavesdropping on the artist singing to herself rather to an audience. In turn, the earthly qualities of her voice ground us in our present, material reality, heightening our sense of self and our surroundings. This tension, between the physical and metaphorical, public and private, runs throughout her practice. With their origins in old English and Scottish ballads, sea shanties or shipboard working songs such as *Lowlands Away* have evolved through the generations, retold and reworked through time. In her rendition, Philipsz draws on its familiar parable to memorialise something lost or absent, while investing in it something very much alive. Helen Little

BIOGRAPHIES AND
WORKS IN EXHIBITION

The list of works are preceded by select biographies.
The final selection of works for the exhibition may change.

DEXTER DALWOOD

Dexter Dalwood was born in Bristol, England in 1960. He was awarded a BA from Central St Martins, London in 1985 and an MA from the Royal College of Art, London in 1990. Solo exhibitions include *Dexter Dalwood*, Tate St Ives, touring to FRAC Champagne-Ardenne and the CAC Malaga (2010); *Endless Night*, Gagosian Gallery, Beverly Hills (2009); *Recent History*, Gagosian Gallery, London (2007); *Dexter Dalwood*, Gagosian Gallery, New York (2004) and *Dexter Dalwood: New Paintings*, Gagosian Gallery, London (2000). His work has been included in numerous group exhibitions such as *Days Like These: Tate Triennial*, Tate Britain, London (2003); Sydney Biennale (2002); *Remix: Contemporary Art and Pop*, Tate Liverpool (2002); *Twisted: Urban and Visionary Landscapes in Contemporary Painting*, Van Abbemuseum, Eindhoven (2000); *Neurotic Realism: Part Two*, Saatchi Gallery, London (1999) and *Die Young Stay Pretty*, ICA, London (1999).

Burroughs in Tangiers 2005
Oil on canvas
184.2 x 210.2
Alan and Sherry Koppel

Herman Melville 2005
Oil on canvas
184.2 x 210.2
Fern and Lenard Tessler, New York

Greenham Common 2008
Oil on canvas
188 x 250
Courtesy the artist and Gagosian Gallery

Lennie 2008
Oil on canvas
150 x 207
Courtesy the artist and Gagosian Gallery

Death of David Kelly 2009
Oil on canvas
203 x 173
Private Collection. Lake Forest, Illinois

Lord Lucan 2010
Oil on canvas
173 x 203.5
Courtesy the artist and Gagosian Gallery

White Flag 2010
Oil on canvas
200 x 250
Courtesy the artist and Gagosian Gallery

ANGELA DE LA CRUZ

Angela de la Cruz was born in La Coruña, Spain in 1965. She moved to the UK in 1987 and studied at Goldsmiths College, London (1991–4) and the Slade School of Art, London (1994–6). Her solo exhibitions include *After*, Camden Arts Centre, London (2010); *Trabalho Work*, Culturgest, Porto (2006); Centro Andaluz de Arte Contemporáneo, Seville (2005); MARCO Museo de Arte Contemporánea de Vigo (2004) and *Larger Than Life*, Royal Festival Hall, London (1998). Her work has been included in numerous international group exhibitions including *Soft Sculpture*, National Gallery Australia, Canberra (2009); *Altered States of Paint*, Dundee Contemporary Arts (2008); *Global Feminisms*, Brooklyn Museum of Art, New York (2007); *Slipping Abstraction*, Mead Gallery, Warwick (2007) and *Transgressions and Transformations*, Yale University, New Haven (1999).

Clutter I 2003
Acrylic and oil on canvas
27.5 x 204 x 267
Courtesy the artist and
Galerie Krinzinger, Vienna

Untitled (Hold no. 1) 2005
Oil on aluminium box and
metal filing cabinet
162 x 10.4 x 9.2
Courtesy the artist and
Lisson Gallery, London

Super Clutter XXL (Pink and Brown) 2006
Oil and acrylic on canvas
210 x 142 x 85
Courtesy TransArt & Co.
Collection, Cartegena

Deflated IX 2010
Oil and acrylic on canvas
153 x 180
Courtesy the artist and
Lisson Gallery, London

Hung XI 2010
Oil and acrylic on canvas
60 x 40
Courtesy the artist and
Lisson Gallery, London

THE OTOLITH GROUP

The Otolith Group was founded in 2001 by Kodwo Eshun and Anjalika Sagar. Eshun was born in London in 1966. He studied English Literature at University College, Oxford (1985–8). Sagar was born in London in 1968. She studied Anthropology and Hindi at the School of Oriental and African Studies, University of London (1994–7). Their two-venue solo exhibition, *A Long Time Between Suns: Part I and Part II*, took place at Gasworks and The Showroom, London (2009). Their numerous group exhibitions include *British Art Show 7*, Nottingham, London, Glasgow and Plymouth (2010); *Manifesta 8*, The European Biennial of Contemporary Art, Murcia, (2010); *Universes in Universe*, 29th São Paolo Biennial (2010); *Star City: The Future under Communism*, Nottingham Contemporary (2010); *Universal Code*, Power Plant, Toronto (2009); *Translocalmotion*, 7th Shanghai Biennale (2008); *Destroy Athens*, 1st Athens Biennial (2007); 2nd International Biennial of Contemporary Art of Seville (2006); *New British Art: Tate Triennial*, Tate Britain, London (2006) and *Homeworks III: A Forum on Cultural Practices*, Masrah Al Madina, Beirut (2005). In 2007, the Group curated and produced *The Ghosts of Songs: The Art of The Black Audio Film Collective 1982–1998* at FACT, Liverpool and Arnolfini, Bristol and co-curated *Harun Farocki: 22 Films 1968–2009* at Tate Modern, London in 2009.

Inner Time of Television 2007–10
13 x DVD and monitors showing 16mm film transferred to video (13 x 26 minutes) of Chris Marker, *L'Héritage de la chouette (The Owl's Legacy)* 1989, vinyl quotations and artist's book
Courtesy The Otolith Group and Chris Marker

Otolith III 2009
HD Video, colour, sound
Duration 49 minutes
Courtesy The Otolith Group

SUSAN PHILIPSZ

Susan Philipsz was born in 1965 in Glasgow. She studied at Duncan of Jordanstone College of Art, Dundee (1989 – 93) and The University of Ulster (1993 – 4). Since then she has exhibited widely in the UK and internationally. Her solo exhibitions include *When Day Closes*, IHME Project, Pro Arte Foundation, Helsinki (2010); *Lowlands*, Glasgow International (2010); *I See a Darkness*, Tanya Bonakdar Gallery, New York (2010); *You Are Not Alone*, Radcliffe Observatory, Modern Art Oxford (2009) and *Out of Bounds: Susan Philipsz*, ICA, London (2008). Her many group exhibitions include *Haunted*, Solomon R. Guggenheim Museum, New York (2010); *Mirrors*, MARCO Museo de Arte Contemporánea de Vigo (2010); *The Quick and the Dead*, Walker Arts Center, Minneapolis (2009); *Tales of Time and Space*, Folkestone Triennial (2008); *Skulptur Projekte Münster 07*, Münster (2007) and *Days Like These: Tate Triennial*, Tate Britain, London (2003).

Lowlands 2008 / 10
3-channel sound installation
Duration 8 minutes 30 seconds
Courtesy the artist, Tanya Bonakdar Gallery, New York and Isabella Bortolozzi Galerie, Berlin

Footnotes to texts:

Angela de la Cruz

[1] El santo se cae, www.youtube.com/watch?v=
MEDgobRMpHM, viewed July 2010.

The Otolith Group

[1] The series was seen for the first time
in Greece itself when The Otolith Group
presented Inner Time of Television at the
2007 Athens Biennial. Before the series
was originally screened in France in 1989,
The Onassis Foundation, the wealthy Greek
funders of the series, offended by George
Steiner's declaration in Episode 4 that
'Modern Greece and Ancient Greece have
nothing at all in common', demanded and
received a disclaimer from Marker and
issued a rebuttal to Steiner at the close
of the offending episode. Not content with
these concessions, the Foundation bought
out the remaining rights from Arte to
broadcast the series in Greece, buried
Marker's work and refuses to grant
permission to release The Owl's Legacy
on DVD.

[2] The Otolith Group, A Brief Meditation
on the 13 Legacies of Athene Noctua, in
Inner Time of Television, published on the
occasion of the First Athens Biennial, 2007.

[3] Between Otoliths I and II, The Otolith
Group curated the retrospective exhibition
and book, The Ghosts of Songs: The Film
Art of the Black Audio Film Collective,
1982–1998 (2007).

[4] This publication was designed by Will
Holder, who also designed the group's
exhibitions at Gasworks and The Showroom.

[5] The Otolith Group talks to George Clark,
www.apengine.org/2010/02/the-otolith-group-
talks-to-george-clark/2010.

[6] Tricontinentalism is named after the
Tricontinental Conference of Solidarity of
the Peoples of Africa, Asia and Latin America,
held in Havana in January, 1966, which can be
seen as the formal initiation of a discursive
space of anti-imperialist resistance. In
the pages of the Tricontinental journal
established as a result of this conference
by OSPAAL, the Afro-Asian Latin American
People's Solidarity Organisation, the social,
theoretical and cultural political thought
of Che Guevara, Amilcar Cabral, Frantz
Fanon, Ho Chi Minh and many others were
brought together as a coherent body of
political work. See Robert J.C. Young,
Postcolonialism: An Historical Introduction,
London 2001, pp.211–16 and Vijay Prashad,
The Darker Nations: A People's History of
the Third World, New York 2007, pp.105–19.

[7] Okwui Enwezor in conversation with The
Otolith Group, 2003 in A Long Time Between
Suns, New York 2009, p.97.

Susan Philipsz

[1] Quoted from 'Susan Philipsz in an
interview with Karin Kopka-Musch', in
Skulptur Projekte Münster 07, Westfälisches
Landesmuseum für Kunst und Kulturgeschichte,
Münster 2007, p.104.

[2] Peio Aguirre, 'When the Body Speaks',
in Susan Philipsz: There is Nothing Left
Here, exh. cat., Centro Galego de Arte
Contemporánea 2008, p.119.

[3] Lisa Rosendahl, 'Let it Breathe',
in ibid., p.153.

Published 2010 by order of the Tate Trustees
on the occasion of the exhibition at
Tate Britain, 5 October 2010 – 3 January 2011

by Tate Publishing
a division of Tate Enterprises Ltd
Millbank, London SW1P 4RG
www.tate.org.uk/publishing

A catalogue record for this publication
is available from the British Library

ISBN 978 1 85437 839 2

Written by Helen Little and Katharine Stout
(Tate Curators)

Designed by APFEL (A Practice for Everyday Life)

Printed by St Ives Westerham Press, Great Britain

Photographic Credits
Jenni Carter, Paulo Costa, Prudence Cuming Associates Ltd.,
Philippa Gedge, Simon James, Dave Morgan, Eoghan McTigue

Artists' Portraits
Taavetti Alin, Houssam Mchaiemch, Ione Saizar

Measurements are given in centimetres,
height before width and depth

Join as a Tate Member or Tate Patron and see all
exhibtions for free. Call +44 (0)20 7887 8888, visit
www.tate.org.uk/members or email members@tate.org.uk

Front cover illustrations, clockwise from top left:

Angela de la Cruz Super Clutter XXL (Pink and Brown) 2006
© courtesy Angela de la Cruz and Lisson Gallery, London
The Otolith Group still from Otolith III (detail) 2009
© The Otolith Group 2009
Dexter Dalwood Burroughs in Tangiers (detail) 2005
© Dexter Dalwood, courtesy Gagosian Gallery
Susan Philipsz Lowlands 2008/10, Clyde Walkway, Glasgow ©
Susan Philipsz, courtesy Glasgow International Festival of
Visual Art. Photo: Eoghan McTigue